Contents

1	Representations and expressions: pictures and practices	1
2	Practice and cultivation	7
3	Human relationships, identity, and popular culture	15
4	Landscapes, nature and health	27
5	Sensuality	32
6	Sacred Spaces	35
7	Artefacts	37
8	Politics	39
9	Negotiation: landscape	51
10	Sources, references and influences	55

Acknowledgements

My thanks go to: Ross Bradshaw (Five Leaves); Ray Hough (BBC, Director of *The Plot* 1994); Richard Wiltshire for his sterling academic collegiateship; the National Society of Allotment and Leisure Gardeners; Harry Palmer (Bloom 98); Colin Ward for his long friendship in allotments; Richard Grassick for his thoughts on allotments; Gert Groening for reflections — over several years — and the Berlin Conference 2000; Ruth Yarrien for providing the piece on Mick Sparkman; Sarah Gore (Pump House Museum) for providing the responses from Dig It 98; Jane Baker for the use of the photograph from Uplands 98 on the cover; Mario Rozansky (Uplands in the 90s); Jeremy Isles and Ian Ettingen-Metters (National Federation of City Farms and Community Gardens) for his persistent enthusiasm; and to numerous scholars who have approached me for ideas on allotments and have shared their thoughts. I would like to thank the thousands of allotment holders who have been prepared to talk with me and show me around over the years, but even more, those whose words I have borrowed for this book.

After the first fifteen years of talking with people, researching, writing and broadcasting about allotments and community gardens, my experience suggests that there is value in making a celebration of them, both for people who have allotments and those who enjoy and experience them. My involvement has been academic, aesthetic and political. These elements are embraced in this book.

DC
January 2003

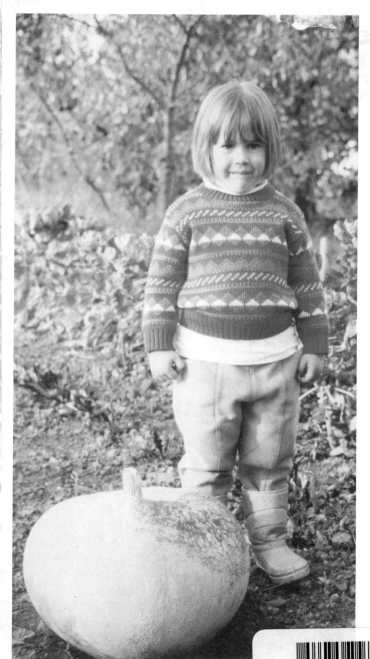

David Crouch

The Art of Allotments: culture and cultivation

David Crouch

Five Leaves Publications

The Art of Allotments
By David Crouch
Published in 2003 by Five Leaves,
PO Box 81, Nottingham NG5 4ER
www.fiveleaves.co.uk

Text copyright: David Crouch

ISBN: 0 907123 78 3

Five Leaves acknowledges financial assistance
from East Midlands Arts

Typeset by 4 Sheets Design and Print
Printed and bound in Great Britain

for Bryony & Thomas

Illustration credits: Jane Baker – front cover and p13; Edward Burra (Lefevre Fine Art) - The allotments *and* Landscape with Beans – pp 3 and 4; Mark Burrell – Chess and whiskey at Charlie's – p36; Maggie Lambert – pp 14 and 38; Mick Sparkman (courtesy of Ruth Yarrien) – pp 7, 50 and 51; Peter Fryer: pp 8, 9, 23, 34, 37 and 39; David Crouch – pp 10, 35, title page and back cover; Dave Thomas – p11; Miriam Macgregor (from *Allotments*) – p15; Sirkha-Liisa Kontinnen (Amber Side Lambton Visual Aids) – Norman Bell, Percy Main allotments – p16; Roger de Grey (courtesy of Flavia de Grey and Tullie House Museum) – Allotments – p24; Jimmy Floyd – Pigeon Crees (with kind permission of the Ashington Group Trustees) – p17; Community Programmes Unit – p18; Keith Woodland – p33; Leora Brook – p22; Alec Leggatt – from *Secret Gardens* – pp 30 and 35; Hansi Durlach – from *To Dwell is to Garden* – pp 25 and 26; Fay Godwin (Collections) – Railway allotment at Saltaire, Bradford – p27; Emma Lindsey – p1 and 28; Justine Kurland (courtesy of *Cabinet:* a quarterly magazine of art and horticulture) – p21; Gwynneth Leach – Siena – p29; Humphrey Spender (© Bolton Museums, Art Gallery and Aquarium, Bolton MBC) p40; Carol Baker – p44; Richard Grassick – p49; Ray Garner – Frog Cottage – p52; David Evans – The Allotment – p6; Dorothy Cloke – War allotments in a London suburb – p25.

1. Representations and expressions: pictures and practices

Emma Lindsey

Allotments have, the papers say, become trendy. Certainly they have developed from being a significant cultural heritage into an increasingly complex and dynamic part of contemporary life. In this book we explore this complexity and contemporary diversity, drawing on allotments' rich traditions. Pictures are an important part of telling this story because, like the plotholders themselves, painters and photographers have sought to represent this rich diversity in equally rich and diverse ways — constructing the art of allotments. The plotholders, however, remain the key players in this book.

Perhaps most importantly of all, the pictures in this book resonate with the voices of people who have, and those who like, allotments. Both the pictures and the voices tell a story of allotments, the landscapes they provide and how those landscapes are worked. This story is one of the lives and culture of the people who have plots, their care for cultivation and the dynamic tensions in allotment holding. These aspects resonate with a wider culture that reinvigorates what the allotment means in life today, and makes the centuries-old struggle for the right to have and to hold a plot still very real.

At the same time as telling stories of the sometimes internal world of allotments and what has been called 'allotment life', these images and narratives contain a larger contemporary culture. That culture includes the debate over the environment and its developing landscape, green issues, rights over land, freedom of expression, and the possibility of exploring values, identities and human relationships.

This book represents a change from the familiar and useful in books about cultivation. *The Art of Allotments* is where cultivation is about human experience, self-identity and identity between people, together with the cultivation of wider feelings about the environment and how people get on with each other. However, this cultivation links with the cultivation of plants and the earth. Having an allotment is to be artistic too, in exploring an individual aesthetic in the manipulation of material things — the compost heap, the rake — and in using plants to fashion a piece of ground. With these simple tools people can fashion a sense of meaning in the world.

Paradoxically this story does not isolate allotments or present them as an ultimate refuge, or remnant of backwardness. It prompts imaginative reflection on the possibility of rendering ourselves a cultural richness that contemporary commentary sometimes suggests is absent or passed. Allotments are part of our living heritage, a heritage that is worked and reworked, in conditions that are partly shaped by wider society and refigured amongst the plotholders themselves in their own interpretation of what matters. Allotments can be useful in positioning ourselves in relation to the wider world and negotiating our relationship with it.

Because an allotment provides a means of freedom to deploy effort in relation to numerous constraints as well as dreams and possibilities, what results on a plot of land can be an expression of many feelings and encounters between people and the ground they use. In this way the plotholder produces a representation of his or her own life; a temporary, changing aesthetic worked with influences even the best plant-cultivation cannot control. Thus the plot represents these connections in the same way that paintings and photographs can, capturing moments and ephemeral

Edward Burra's painting, The Allotments, depicts a solitary gardiner on a neglected site. The crow in the picture stares disconcertingly from the side, rendered in bleak colours. In contrast Burrell's painting on page 36 celebrates the strange childhood observation of his father and his allotment, exaggerated in the bright colours he uses. His recall creates a fantasy that can also be the idyll that many allotmenteers identify with their plots, as is explored below.

results of a dynamic activity. Allotments can be places of imagination. They can be haunting, uncomfortable places too: negative and unsettling. Tony Harrison's poem visualises the left-over character that some alotments have. He identifies the hard edge of coping, difficulties with feeling isolation, and just the hard work of allotments:

"Choked, reverted Dig for Victory *plots*
Helped put more bastards into Waif Home cots
Than anywhere, but long before my teens
The veterans got them for their bowling greens."
 [Allotments, 1974]

"Dig for Victory Plots" was the name given to allotments during the war effort to encourage people to grow more of their own food.

3

At the same time, however, 'allotment' implies sanction by others; being allotted a piece of ground on terms prescribed. The etymology suggests small compensation for historical loss of land, for example by the Enclosures in the nineteenth century, and of survival in crowded cities and coping with poverty [Crouch and Ward, 1988]. The characteristic humility of the allotment story is mixed with strong political struggles that have exemplified its history. Ten generations further on from the Enclosures the situation is more complicated. There are certainly still many people who find a financial supplement in what they grow and produce, and a plotholder can find a refuge there from a crowded home. 'Holding' suggests a tenant-landlord relationship and landlord

Edward Burra: Vegetables

control, and the impermenance of annual renewal. The paradox is that plotholders usually feel they 'own' the plot.

"I have always passed by allotments and watched with envy. I still dream of one day having my own."
[Pump House Gallery Exhibition]

The meaning of control, escape and of discovery that permeates what allotment holding means today puts the allotment in a much richer and more diverse light. In *The Allotment: its landscape and culture* Colin Ward and I argued that the word allotment was both outdated but readily identifiable. Since the first edition of that book things have changed. The label remains identifiable yet is still outdated. Alongside the allotment, Britain has seens the significant arrival of Community Gardens, sanctioned in high places by a launch of the Federation of City Farms and Community Gardens at the House of Lords in 1988. These Gardens exemplify the community context through which plotholding becomes increasingly important. The new name shifts allotments explicitly into their new position in contemporary life and in locally-centred care for the environment.

There is a resonance between paintings and photographs and the aesthetics produced in the humble or heroic effort of working an allotment. Dreams are an important part of what is often represented as only hard graft. Artists' and photographers' dreams are often reflected in their work. Plotholders dreams can be expressed in the bits and pieces used, in the way the ground is worked, in reflections on time spent at the plot and in memory and anticipation. Allotments embody the negotiation of individuals with culture and place. People who observe them as they cycle by or walk

down the street or watch a television film about allotments talk of them as romantic, desired places. They also represent contemporary cultural tensions between views of how places should look. The paintings and photographs in this book represent these diverse components through the artists' own perceptions and values. The voices of plotholders evoke what they feel and do.

Inevitably any exploration of allotments today prompts questions on their future. Whilst a new name is not enough it provides a useful focus for thinking about that future. The House of Commons' *Inquiry into the Future of Allotments* (House of Commons, 1998) provides such a springboard. Allotments emerge in the new millenium reinvented and more politically dynamic than for over a century.

David Evans: The Allotment

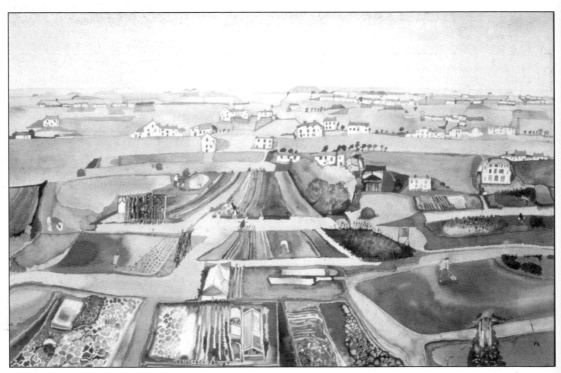

2. Practice and cultivation

Allotment holding occupies people in very physical activities. The plotholder drags vegetable material to the compost, pulls tools through the ground with sharp or rhythmic movements in digging. Seeds are carefully felt into holes and drills; fingers are pushed through the earth to find rootcrops; arms brush against sharp spines when picking or pruning fruit. Corrugated iron is pushed into shape; disturbing earth and turning compost raises a pungent smell. Cultivation uses all the senses. Everyday practice on the plot begins with unstructured material: a piece of ground and a heap of sticks; a box of plants; packets of seeds; and a bundle of ideas of what might be done with them. Presented with this array the plotholder begins to make sense of it all. At the end of the allotment day the new arrangement made speaks of effort and struggle, the depth and limitations of cultivation.

Mick Sparkman (courtesy of Ruth Yarrien)

7

Peter Fryer

Using these materials and our bodies in a very physical way helps us to make sense of what it is to have a plot. A great deal of plot-holding is about doing; activities, tasks, moving things and settling them in. That physicality reaches well beyond the limits of following the mechanical details of allotment cultivation manuals, although these can be a valuable resource through which working the ground takes place. Gazing at the view is not what allotments are about, although it is very important to be able to look over that view of the cleared rows, the prepared ground, the work to be done, the fattening crops, the revitalised shed. But 'the view' is something with which the plotter interacts, produces, and paintings and photographs can capture this dynamism. In this way, the plot is for both reflection and for production.

Moreover our ideas, feelings, emotions and desires shape what we make of the plot. This means more than physical exercise, ordering of pieces of ground and regulating what grows — important though these may be. The whole thing is a sensuous experience, a means of finding expression in life. Doing an allotment is made up of the cultivation of plants and of peoples' lives and their cultures.

Peter Fryer

Indeed, culture is reworked in the process of cultivation. Through doing things like this it is possible to make sense of the world, to construct a practical knowledge that also helps us relate, or contrast, allotment-holding with the rest of life.

Knowing who we are arises not so much through received learning, but through working our own lives, through our encounters with other people, with ourselves, with material and imagination. In that sense it is the mixture of metaphor and the apparently simple material artefacts, that forms the stuff of allotment gardening.

"My mum and dad had an allotment. We were all taken there on Saturday afternoons and from there we could hear the cheers and

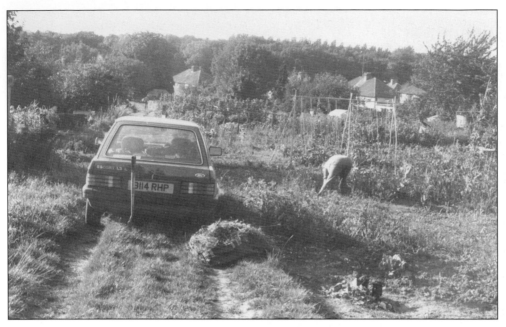

David Crouch

groans from St James' Park football crowds. We always knew the score before we saw the result on the telly. My first growing was in the old leek bed, me and my brother were each given our own little plot. Mine was where the old fellow before us had grown competition leeks so the soil was fine and crumbly and rich with nutrients. My carrots were the best ever. I always complained at being taken there, but I found plenty to do, plenty to look at. But I was always ready to go home long before mum and dad. When I got my own garden I realised how much time gets eaten up when you are in it! I now live in a flat in Hulme with a small balcony. I really miss my garden, I only had it one season, but I caught the bug. I have a couple of rows of beans growing and a couple of tomatoes on the balcony but it's not the same. There isn't enough to do. I want an allotment, but I fear

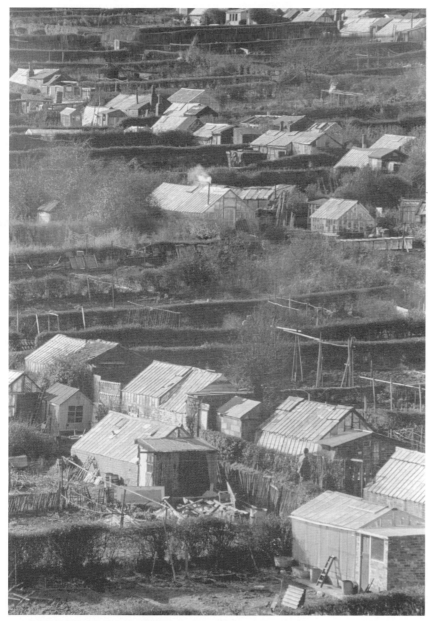

Dave Thomas: Allotments, Sheffield

that if it wasn't really on my doorstep I wouldn't make the effort. I worked on an organic farm in Germany a couple of years ago, that was wonderful. I thought I wouldn't be strong enough but I worked all spring and summer and got strong and brown. It was a wonderful time cycling and walking outside the whole day then home again. It's important to have something growing. It's so important to feel the earth. To be outside seeing the way seasons affect the earth, how important rain is, what happens when the sun shines, it makes us real. It reminds me that I am dust, the stones are my ancestors. We were born under the same star."
[Pump House Museum Exhibition]

"I had an allotment in Colne. Only grew grass and encouraged wild life on it. It was a nice place to take my girlfriend at night."
[Pump House Museum Exhibition]

The artists' creativity resonates with the creativity of the allotment holder. Creativity is worked through vegetable seedlings, fruit bushes, plant cuttings, wooden stakes, bamboo canes and water butts. In the Soviet Union in the 1980s allotments provided a rare sanctuary for creative expressions of personality and individuality [Crouch and Ward, 1988]. Sheds were built in a fantastic variety of ways, some taking on the appearance of old churches, each wrought through the creative work of the individual

plotholder. Everyone has a unique approach. Work, as an exchange with nature, can be of the most basic significance for human well-being. Doing ordinary things can constitute creative work and enable the realisation of human potential. Because the allotment represents an almost secret space for many people, unlike their lives 'on show', it becomes a space of greater freedom than is possible elsewhere — allows them to be more liberal in the way they behave.

The numerous close-up small spaces in which allotment cultivation happens provide intimate experiences of the self in relation to nature, and to material objects. There are opportunities for poetic reflection and imaginative play, nurturing feelings of security. On the other hand, they can provoke anxiety and feelings of being unable to cope.

These diverse experiences were captured in an artistic event in Birmingham — *Bloom 98*.

The numerous practical components of doing allotments were realised in a multi-media project on Britain's largest allotment site, Uplands in Handsworth, Birmingham during the summer of 1998. Allotment holders at Uplands are of many different ethnic identities, in particular European, African-Carribean and Indian. They have a recent history of involving the wider community. School groups, youths working from social services and luncheon clubs for the elderly meet in the club house. Through negotiation with the plotters over a number of months, intervention artist Harry Palmer organised a number of different artists to perform. The

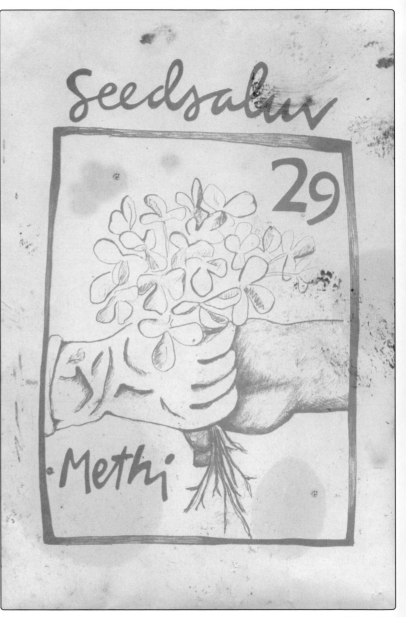

Bloom 98

event was staged on several plots one long evening in July 1998. The performance included Umbrella Gardening, where one plot was transformed into a field of umbrellas planted in the earth. "Our expectations are confounded by a paradox of light and sound of rain." [Martin Burton, Bloom 98]. Dozens of umbrellas were planted in the ground and lit beneath as the evening progressed. This lighting was accompanied by the projected sound of falling rain that had an effect also of sounding like roots moving as they grow in the earth.

Harry Palmer directed the event at Uplands. He wanted to use this performance to convey what he felt allotments expressed: a quintessential British activity which crosses boundaries, transcending monetary and class values despite the pressures for its alternative use seen as "more suitable", "more worthwhile" and "better for the economy" echoes of

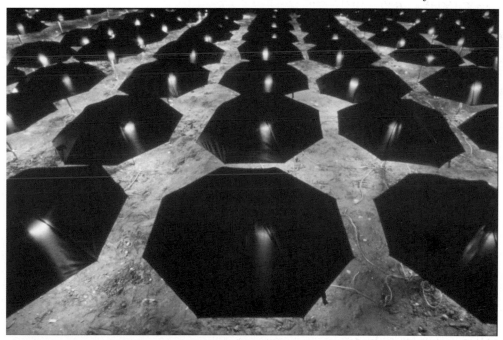

Umbrella Garden: Jane Baker

which are voiced from above. Uplands was chosen not only because it is a large space (400 plots) and spread over a hill, providing a dramatic setting for spectacle. Uplands plotholders come from many different nationalities, displaying diverse ways of cultivation, ethnicities and a significant level of associative activity that includes activities involving the local community during the year. This provided a context for performing a number of ideas. All the performances used natural objects — earth, branches, seeds.

In another plot dozens of yellow plastic gloves were planted in the ground, rising up like plotholders struggling with their land and with their right to hold land.

Blissbody also tended their allotment/installation through the early evening, with a ritualistic performance at dusk. The artists lit fireworks and set light to plaited twigs. Situated on the brow of a hill in this site the performance made a significant spectacle in the dark.

Maggie Lambert

Other features of the evening included Seedsaluv's 'collaborative seed packet with allotmenteers to reflect and celebrate culturally diverse and organic gardening practices.' The seed packets they produced were designed by an artist and filled with seeds given by plotters, representing the different ethnic cultures. The View from the Shed celebrated 'the wider universe… struck down to the scale of the allotment'.

3. Human relationships, identity, and popular culture

Getting on with each other is important on an allotment site because the margins of what any one individual does are not clearly defined. Many plotholders don't easily get on and romanticism has its limits. However, a prevailing, if perhaps exaggerated theme amongst allotment holders, is the significance of friendship.

Whilst the garden centre warehouses offer means of circumventing low-scale innovation, it is the potential for working with simple materials that matters to most plotholders. They can create spaces and ripen plants that work with the grain of how they feel rather than against it. This includes exploring non-commercial relationships, friendships, identities and getting on together. Allotment holding can be a means of negotiating contemporary life, and seemingly standing outside it.

Two plotters, a black man in his seventies and a white woman in her sixties, talking express values and relationships nurtured amongst their plants:

"We learn things from each other. You are very social and you are very kind. You make me feel good, you don't come and call at me. Things in your garden you always hand me, little fruits, which I have valued so much."
"And I've learnt from him. I've learnt some ways of planting, I've learnt real skills about planting, Jamaican ways of growing and cooking. And I've also learnt about patience and goodness and religion, too. It all links in."
"If you give somebody anything they say 'where did it come from? I say I grew it

Miriam Macgregor (from Allotments)

*myself. You feel proud in yourself that you
grows it, you know, if you get it from the
supermarket some of it don't have any taste.
On the allotment you plant something and it
may take nine months to come to."*
[Crouch, 94]

The north-east of England has a mythical status in
popular allotment stories, and is often regarded as
the key — if not the only — place where there are,
and have been, allotments. The reason for this is
that the north-east is the place for the eccentric and

Sirkha-Liisa Konttinen (from the River Project): Norman Bell, Percy Main Allotments

committed pursuits of leek-growing and keeping pigeons. Some sites are crowded with so many bird lofts that they resemble Wild West shacks, often brightly decorated to guide the birds on a secure flight home. The north-east is rightly renowned for its leek growing. Plants are grown to prize-winning girth, with the use of curious potions. Some communities have competitions bearing International Trophies and competitors come from within a twenty mile range. Pigeon races can start in France and people use birds bought from Japan, but

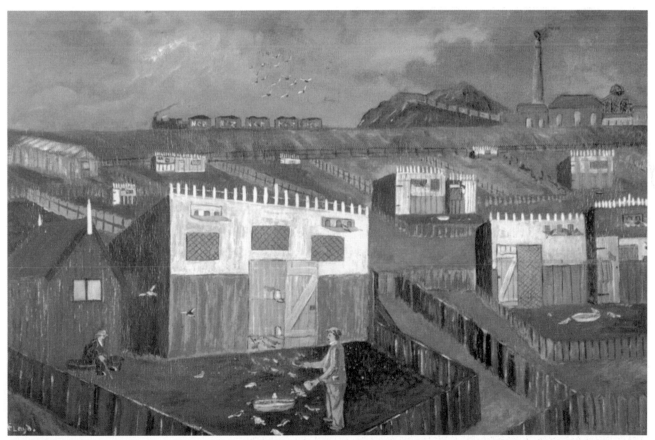

Jimmy Floyd: Pigeon Crees

leek competitors rarely travel to the event from beyond the immediate community.

The tradition of leeks and pigeons has been an important part of the coal mining culture that extended from the north-east down to Nottinghamshire and into South Wales and Kent. It was in the north-east, however, that a unique local group of miners turned to painting and drew on their local environments for their work. Pigeon crees provided a fascinating object for study. Here the same culture represented itself through allotment cultivation and through paintings of that allotment work and its cultural identity; both rich components of local popular culture, exemplified in the Ashington Group (*see Pitmen Painters*).

In many areas of Britain allotments recall wartime and childhood memories. These earlier contexts are reworked through everyday experience. Increasingly

Community Programmes Unit, BBC

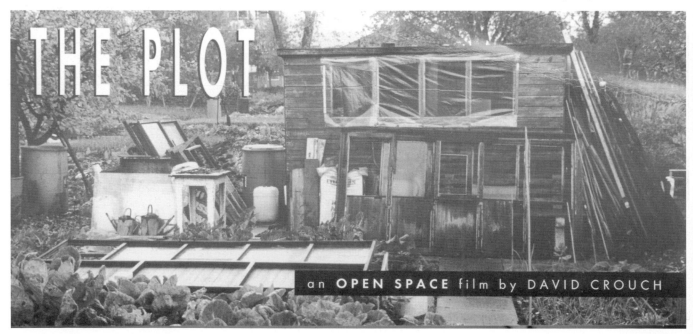

this appears in television and literature. *The Ballad of the Ten Rod Plot* (1992) portrayed a year in the life of an allotment site in Norfolk using music by The Albion Band, including a song about *arthur-itis*. Amarani Films' *Vegetable Plots* did another story, this time at Ponders End in north London. The film culminated with a fire in the plot-holders' clubhouse, its refurbishment through the effort of the plotholders and a celebration of their success at a party that included a karaoke singer re-working Elvis Presley's "If I didn't treat you just as I should have...". This author made a film in 1994 with Ray Hough, then producer with BBC Community Programmes Unit — imaginatively called 'The Plot'. In that film we used Billy Bragg's rendering of Blake's *Jerusalem*. The main soundtrack was made by Sabrina, a tattooist, and her partner, who create music using vegetables from their allotment, being chopped and cut, chewed and savoured.

Perhaps the most significant change in media popular culture during the last decade has been the arrival of allotments as artefacts, although stereotypes of allotments as the preserve of old people struggling hopelessly alone against the discomfort of digging a plot rather than buying from the supermarket, persist. Allotments are frequently the subject of aesthetic interest and curiosity. The *Guardian's Space* magazine headlined a feature as allotments being 'trendy'; *Room*, IKEA's magazine, featured allotments in a double double-spread, and the *Financial Times* excited over the number of academics who look after a plot. *Sainsbury's Magazine* featured allotments in its spring 2001 issue. In the mid-1990s the *London Evening Standard* celebrated allotment fashion with rural-Islington chic. Some

Channel 4 Television

ALLOTMENTS
a viewers' guide

CHANNEL FOUR TELEVISION

local councils present allotments with a renewed image that resonates with the human and 'green' character of allotments.

Exploring the tension between tradition, class struggles over land and a newer interest in allotments as interesting and poetic, a theatre company in the north-east of England staged an allotment opera that was performed in many cities in the north of the country.

Andy Jackson and Jeremy Warr write opera and used their knowledge of allotments to portray a tension between tradition, class struggles over land and a newer interest in allotments as interesting and poetic. Opera Publica, a theatre company in the north-east of England, staged their work in many cities in the north-east during 2000. Allotment holding can provide drama — in the tension of fighting to save a site from development, in the events that befall the gardener thoughout the year.

Allotments are increasingly multi-cultural, multi-ethnic and drawn from many different parts of the community. Stands of okra and large beds of spices and specific ways of growing crops mark individual and cultural identities, making plots distinctive and diverse and providing the catalyst for new networks between plotholders, for whom sharing a site may be the only means of contact and mutual discovery.

"If it hadn't been for the Cypriots on our allotment site we'd never have grown artichokes. They're easy. And delicious. To us allotment sites don't look right any more if there are no artichokes growing there."
[Pump House Gallery Exhibition]

Opera Publica presents **The Allotmenteers**

by Andy Jackson and Jeremy Warr
Painting by Tom MacGuinness and used with kind permission of the artist

A brand new musical play about urban regeneration, love and vegetables.

Poster designed and printed by **Red Flag Press** 01223 236786

ON TOUR IN 1999

northern arts Supported by DURHAM COUNTY COUNCIL Arts, Libraries & Museums Department DERWENTSIDE LEISURE WEAR VALLEY ARTS

Women from Bangladesh sustain and develop their identity in getting together to work their allotments in Bradford. In Nottingham allotments allow rural Kurdish refugees to keep their hands in the soil.

Allotments cross numerous aspects of social relationships but also provide a means through which those relationships may be developed outside the immediate allotment community.

"A lively allotment society can negotiate, liaise, work with local councils, local firms, sponsors of a variety of kinds and local voluntary groups, social service departments, environmental and food growing organisations, civic trusts, to develop events,

Justine Kurland

21

*to encourage people to visit a site for
ecological work, and enabling youngsters to
discover their confidence and self-repect in
repairing buildings in the company of
other plotholders, in ways that give people
responsibility, a responsiveness to the
environment…"*
[House of Commons Inquiry… p xii]

People who have allotments are as likely to be
under thirty-five as over sixty-five, or
anywhere in between.

*"[These people come] as close to the
definition of good people as any I've seen.
Certainly I'd go into the jungle with them.
Not least, because I know they'd
immediately start uprooting the nasty
creeping vines and poisonous weeds, and
plant rows of tasty broad beans."*
[Victor Lewis Smith, *Evening Standard*,
October 1994]

Most people turn their sod because they want
to grow food, enjoy the 'crack' and expand
their imagination, but for some there is an
ideological need to work the ground, to sustain
the environment, and to provide a particular
quality of food for the family. Ideology can be a
very important reason for having an allotment
and a central part of what it all means.

*"… my allotment is of central importance
to my life. I feel strongly that everyone
should have access to land, to establish a
close relationship to the earth… essential
as our surroundings become more
artificial."*
[Carole Youngson]

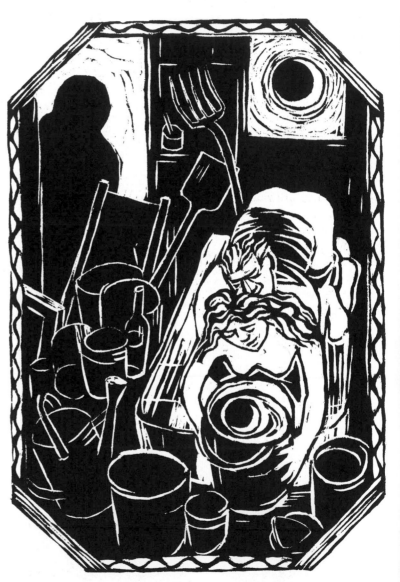

Leora Brook's image starkly depicts the masculinity of allotments…

"... and they catch up on a bit of old city gossip, but mostly Esta's rambling about this and that, about raised beds and storms in South America, about photosynthetic karma, about a new woman that Esta is friends with called Sarah, and the others are agreeing and nodding and chuckling carelessly."
[from *Plot 61*, Matt Black)

But it is not all like that. Women can be misunderstood by traditional plotters. Liz Randell told Peter Fryer: "there was a fellow over there and he saw me come down one sunny day and he said: "Och! What have you come for? Have you come to sunbathe?" And I sort of stuck my nose in the air and said "No! To work!" and stalked on."

...but as the photograph by Peter Fryer illustrates, there is a gentle, feminine component if cultivation, even when it does include the hard work of dragging weeds out and digging hard.

"My friends and I used to have an allotment in Odense, Denmark. It was very nice and we cultivated carrots, cucumber, lettuce, leeks and herbs difficult to find in Denmark a few years ago, like coriander."

Roger de Grey: Allotments

Hansi Durlach (from To Dwell is to Garden)

War Allotments in a London Suburb, Dorothy Cloke

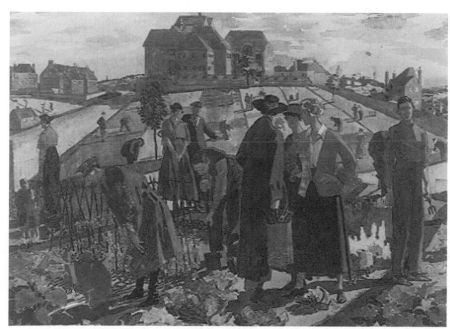

When the weather was nice, we organised barbecue parties and since my friends and I come from Iran, our food was special for Danish taste [kebabs and lots of green salads]. Our Danish neighbours were curious about our food and traditions and after overcoming initial shyness we could talk to each other and become friends. All thanks to our allotment." [Pump House Museum Exhibition]

This is a market where you can give and take, with pleasure.

"I'm disabled, and couldn't cope with an allotment. But my friend from Huddersfield has one. She hasn't had it long, but she's produced some beautiful vegetables. — a potato variety that I'd never heard of, which was delicious, and some lovely beans. Every so often she visits me with a gift from her garden. So I share and enjoy and treasure. And so we enhance each other's lives… the producer and the consumer — both sharing in the joy of creation."
[Pump House Museum Exhibition]

For most people an allotment is not an ideological project. Yet plotholders frequently develop attitudes and values about the environment and the value of other people. They share tips, produce and plant cutting, taking surplus to a local hospital. Cumulatively, ways of thinking and acting adjust. Ideologies may be less pre-figured in one's life and politics, than discovered and constantly reworked.

Hansi Durlach (from To Dwell is to Garden)

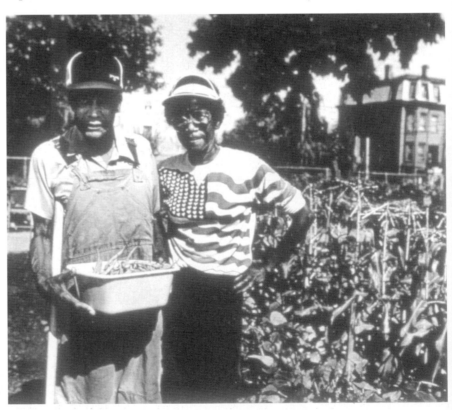

4. Landscapes, nature and health

Working a plot provides insights that shape the way plotters make sense of the environment. We understand the environment less through learning what happens through dramatic images of exotic places we may never see, than through our own intimate and [extra-]ordinary encounters with it in our own lives.

Railway allotment at Saltaire, Bradford:
Fay Godwin (Collections)

Allotments are landscapes that are regulated units of particular character. They change and continually defy classification. Allotments are not urban or rural, but both. These are unusual dynamic landscapes people make themselves, in a mixture of control and freedom. Looking across the allotment plot the plotholder feels involved and part of the landscape itself. For the plotholder the view is merely part of that more complex encounter with things that engage the complexity of senses. We inhabit this place as an

Emma Lindsey

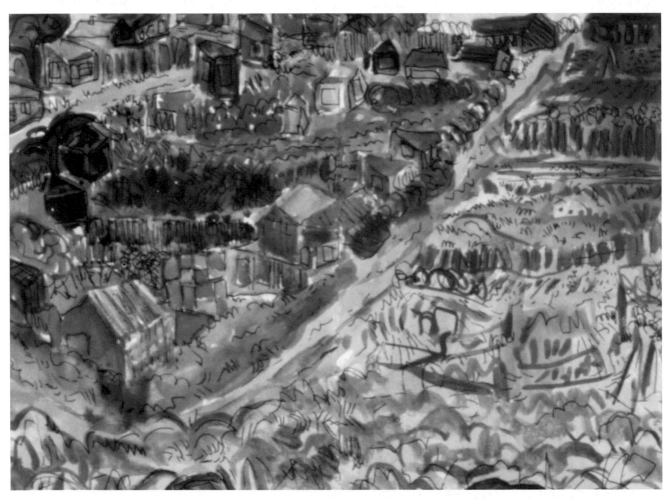

aesthetic experience. An allotment on the edge of a village can make being in the countryside very different from a post card view. An allotment in the city becomes countryside. This was reflected in the title of a book of allotment essays by Michael Hyde — *City Fields, Country Gardens* — suggested by someone without an allotment.

Gwynneth Leach: Siena

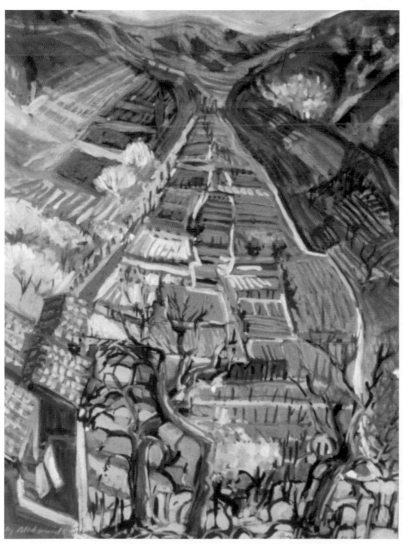

For a plotter using a site in the middle of Birmingham surrounded by terraces of houses and blocks of flats it is possible to say:

"We come hear for the peace and quiet... On a nice summer's day you feel like you're in the country, it's like being in the countryside in the city."

[*The Plot*, 1994]

Allotments confuse what dominant culture has made of the rural and the urban. Allotments do not comply with abstract ideas of open, rolling country and are full of complex interactions between people and nature and structures. Moreover they confound the neat ordering of land that city designers proscribe. Instead, the notions of the city and the country that allotments provoke are made from fragments of what plotholders do.

Like most gardening activities, allotment holding can include the ordering and control of nature, working with or being led by nature. A dynamic tension is created where the allotment holder can adopt many different roles. This can often include negotiating between different pressures, caring for nature yet making sure it does not subvert the process of providing food and other crops. Producing healthy food is a key

29

purpose in having control over what we eat. This is for many symbolised in the allotment.

> *"My father is Ukranian and has an allotment. He has always grown vegetables. He is 84 years of age and has poor eyesight and is crippled with arthritis mainly in his hands and knees, ankles and spine but will not give up the allotment. For years he has said that the produce we buy is tasteless and sprayed with chemicals and artificial fertilisers. My father is a very fit 84 year old who lives off the land — he collects his own seeds from vegetables and grows fruit. His only vice is that he smokes — he even grows his own tobacco. He could do with help with his bees."*

Alec Leggatt (from Secret Gardens)

The physical exercise that allotment cultivation affords is important, but the health benefits may be greater than this:

> *"I have lived in flats all my life and currently live on a busy council estate. I have no hope of ever being able to afford a garden, since my work is rather low status and underpaid… My allotment has enabled me to find a side of myself I did not know existed and it also helps me to cope with an extremely stressful job in a stressful city."*
> [House of Commons Inquiry: The Future for Allotments, 1998, p xi]

Food growing is important in itself. Allotments, with self-made sites and produce, are part of the wider world of sustainable food-growing that is also sustainable in its use of the land. There can be pleasure in this food-growing and in the self-conscious role it has in relation to global food issues. Allotments and community gardens featured alongside ecological food cultivation and small plot farming in Sri Lanka, the Gambia and Japan in a food growing conference at Berlin in the summer of 2000.

Increasing numbers of plotters are ideologically disposed to recycling materials, germane to the way many allotment holders have needed to be careful about the use of resources they have at their disposal.

> *"I am convinced that this has less to do with saving the planet than saving money."*
> [Ray Garner, 1994].

As Ray Garner comments, recycling may have been developed through necessity. The onset of chemically assisted cultivation in the mid-twentieth century confused this tradition although it was welcomed as a means to save time and make growing easier, and apparently 'cleaner'.

5. Sensuality

Moving plants and earth, humping material to the compost heap, gathering twigs, making a bonfire, dragging and hauling material across earth... all this leads to very direct contact between our bodies and the material world. In all these tasks our bodies make a sensuous engagement with the world around us.

> *"Working outdoors feels much better for your body somehow... more vigorous than day to day housework, and there's more variety and stimulus. The air is always different and alerts the skin... unexpected scents brought by breezes. Only when you are on your hands and knees do you notice insects and other small wonders."*
> [Carol Youngson, Co. Durham]

The allotment is remembered through the taste of crops at the table. We make sense of the place by our direct contact with it — working, imagining and being busy. The plotter reworks the rectilinear regularity of the plot and its regimented provision. The vegetation softens the hard edges of each plot and the diverse ways each plotter works changes that apparent regimentation.

When I use loose netting over raspberries for protection there is an almost stolen, secret, intimate, sensual delight in lifting the nets to seek out the seduction of the fruit. Allotment produce can be figured out of the rows and bags we take home to other parts of our lives, extending the plot significance to the kitchen table.

The experience of taste is not only one of deploying the acute senses. The taste celebrates the richness of the results, of having something yourself, of knowing the care that went into it of which the momentary and remembered taste speaks, with a little help from the rain. In the taste is the fresh air, the joy of growing and the way it was grown, of watching, over the weeks, the opening of the fruit, the swelling of the greenstuff, the ripening colour, the gradual arousal of the whole process that includes the smell that foreshadows the taste when picked; the feeling that something is ready. These components, the steps of cultivation, may not be ideal or follow the gardening manual, but they are our own.

In declaring that they own a plot, people override the financial and legalistic meanings of ownership and express effort, love and care; the investment of their emotions as well as time. Ownership is sensual.

Feeling is important for allotment holders both as emotion and as physical encounter. It is not the view that matters. This is not because appearance and being well-kept does not matter [to meet the checks for 'best kept allotment of the year' or to avoid plot appropriation for lack of maintenance]. It is rather because touch and other senses are crucial in cultivation. Finding potatoes, feeling under the

Keith Woodland

boughs for gooseberries, checking where the twine is behind the stems and caringly positioning wayward tendrils of runner beans. Touch matters. Touch is a manipulative sense but also a sensuous feel. Touch expresses care, and love, as well as pushing things into place. Touch provokes smell, as anyone who has thinned carrots or nipped out overgrown tomatoes or checked the curved swell of parsnips growing and ripening will testify.

An allotment plot can be an intimate space, even when located amongst a hundred others. Here politics and struggle can be forgotten and dimensions of the imagination opened.

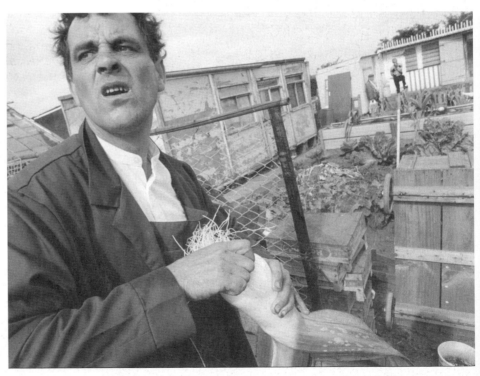

Peter Fryer

6. Sacred Spaces

David Crouch

Alec Leggatt
(from Secret Gardens)

Allotments can be vested with love, care and imagination and because of this, they can be a sacred space. These everyday sacred spaces may resonate with remembered pasts. That deep feeling may engage values beyond filling the crop basket and may be very personal.

> *"My allotment means peace and quiet, relief from stress; it means creativity, the love of creation, … it means everything to me. I would not be anywhere in the world but here."*
> [Deirdre, The Plot, 1994]

> *"People gain not only physical sustenance from the land but spiritual well-being through cultivation, growing and their relationship with the seasons."*
> [Pump House Museum Exhibition]

> *"I haven't spent much time on allotments but two times I remember, just felt right in the place and so good. This is the second year I've tried to grow stuff and even though I've done only a little bit I've got lots of satisfaction from it. I love the character of allotments, the ramshackle sheds and bits and pieces everywhere."*
> [Pump House Museum Exhibition]

This attachment to a plot of ground can be symbolic and felt as being part of the world in a very intimate way; a feeling of dwelling. Sam Bass Warner's evocative text *To Dwell is to Garden* expresses this very directly. To cultivate is to feel through touch, to experience an identity in looking after a piece of land, in the sense that every piece of looked after earth is home to somebody.

Within the sacred it is possible to include the other-worldly, the mysterious, but also the exaggerated — or perhaps just heightened — interpretation of memory or encounters with the strange, that can be part of everyday activity.

"Any depressions that you might have, they just physically go within minutes of you getting down here and sitting down. I think you're just away from the home environment — not that we don't get on at home, but it's a fact that it's nice to be able to come away, if you want to come away, and have your own little bit kingdom. This is my little bit kingdom."
[Tony Scott, a plotholder in inner-city Newcastle]

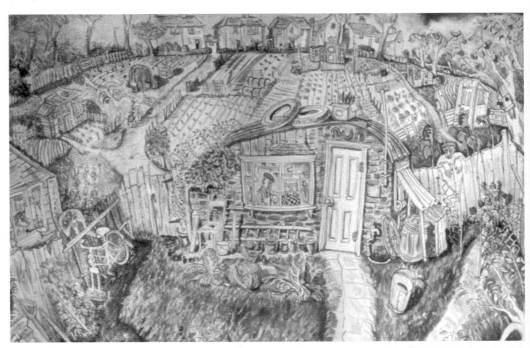

Chess and Whiskey at Charlie's
Mark Burrell

There is of course much paradox in this. Allotment holding happens as a dynamic tension between freedom and control, imagination and rules, emotion and procedure; the tending of nature and its control. These paradoxes are embodied in the word cultivation. Cultivation in the allotment combines privacy and friendliness. Compare the closely-watched preparations before leek shows with the fun of other plotters wanting to talk, at times inconveniently.

7. Artefacts

The material objects that plotholders engage with through the way they use and move their bodies, touch the ground and pull up weeds, provide their own meaning through how people feel about life at a particular moment. The material objects become metaphors for all that this encounter with things means: the compost heap, home freezer, the shed, the shovel and the seed. Seeds represent a chance to grow things better next season and the interest that younger and newer arrivals have in sustaining allotments. The compost heap represents caring for the materials used and being able to invest something

Peter Fryer

for the future. The home freezer has largely taken over from the earth clamp for storing potatoes and carrots and bottling beans, and can embody the result of a season's work. The need to keep working the ground is spelt in the shovel, and the shed epitomises not only the creative product of labour but the security of somewhere to take a break, to store materials and to dry food. The shovel reminds us of the political effort often necessary in holding on to an allotment site in the face of its potential loss to development.

Allotment holding can change our view of the world. The environment becomes part of our lives rather than detached from them. Memory may be reshaped in the process, interjected with recent events and encounters — trying out new kinds of vegetables; sitting back to enjoy the view; the way we grow things as well as what we grow. The artefacts of the allotment echo the way we feel. Cultivation may be less of a separate tool-kit of when to plant and what to avoid, than a much more complex human activity where nature is a crucial partner.

> *"Plants. Food. Flowers. Peace. Chat. Tea in flask. Shelter in the shed. Somewhere to escape to. My patch. Repetitive flask and tasks."*
> [Pump House Museum Exhibition]

While the city and suburban street may increasingly be considered a channel for cars and less the site of human friendship, it is around spaces like the allotment that the street becomes animated. Allotments defy ideas of what is city and what is country in a way that contradicts the compartmentalisation of everyday life. The environment is continually remade, in imagination as well as on the ground.

> *"In your little island of the allotment, with this shed place where you pretended you lived."*
> [Charles Tomlinson, *The Plot*, 1994].

Maggie Lambert

8. Politics

Politics on allotments take different forms. One is the often staged politics of contesting the loss of a site to development. This can involve political organization — working out schemes of action in order to debate, to protest, to publicise the case. Another type of politics is more diffuse — negotiation, sometimes with other plotholders, over cultivation or the use of communal areas. These too can be hotly contested and can reveal deep tensions about ways of growing things that may affect neighbours' plots — pesticide sprays or weed seeds on some organically-tended plots blowing across the site, for example. More loosely, having an allotment means getting on with other people and at times that can be difficult. Another type of politics is working out how one feels about what one is doing, working out an identity in what is going on, developing ideas and values concerned with using land. Many plotholders have little desire for politics in the traditional meaning of the word. They frequently explore their own agency through these apparently softer, but possibly deeply significant practices, by taking direct action in looking after the environment.

The big issue of contesting the loss of an allotment site has a long history from the Civil War Diggers through struggles to secure land, and to keep it, throughout periods

Peter Fryer

39

of renewed urban development. Open spaces that include allotments are featured as significant in the Government Report *Urban Renaissance* (1999), as their importance is acknowledged as part of making cities 'livable'.

Allotments were the subject of top-down politicisation during the 1960's Inquiry that sought to rationalise and bring order to allotment land and its use [Thorpe Report, 1969]. Its recommendations included the redesign of sites to a more urban landscaped aesthetic, including replacing 'ramshackle' sheds with concrete blocks of individual secure boxes for equipment, providing club houses to meet and to shelter. The Government at the time did not act on these recommendations. The re-design proposed was alien to the character of allotment holding, and the proposals would have involved considerable expense. This report, however, resulted in a greater awareness of the value of allotments and of the need at least to make as efficient, effective use of the land as possible. Both concerns are difficult to resist.

More significant perhaps was the spotlight directed on allotments by environmental groups during the following decade. This gave impetus to the wider interest in allotments that developed through the last twenty years of the last century. This crucial change brought more ideologically-committed plotholders alongside those traditional plotholders who identified more with the work allotments required rather than having any explicit interest in the environment. However, in the sustainable tradition of plot-holding, most plotholders already tried to look after the environment, disrupted only by the enthusiasm for

Humphrey Spender

40

heavily-advertised chemical assistance to cultivation during the mid-century. However, it is important to note that political activity is not limited to young activists.

> *"Five times in the city we have been moved from site to site. This site has been under threat for nearly as long as we've been here. I've said I'll chain myself to the gates this time. I feel very strongly about it. Building. We've fought it this year and we shall fight it again. They'll have to do it over our bodies."*
> [Nora, in her late sixties, Northampton].

Allotments began to attract the curiosity of the ecologically politically active. Journalists and academics caught this interest and provided a ready public voice for the diversity of issues that allotments could embrace. These shifts intensified during the last decade or so of the last century and set the scene for current debate. Throughout these decades local allotment movements often became fiercely active in defending and promoting their interest and their rights, that remained in law, to be able to cultivate a piece of land. During the first and second World Wars, allotments signified the fight for food amidst external difficulties and containment. The new fight was, as one hundred years ago, for land for ordinary people to use.

A recent poster depicts an historical icon from the second World War. The original, the 'Dig for Victory' poster, was used to promote allotment food growing in order to overcome food scarcity. That poster depicted a boot pushing a spade into earth. The new poster features a young person bent, holding a spade, digging up tarmac, with a background of buildings and a modern windmill. This time the struggle is to recover land for cultivation from a modern society that appears to prioritise buildings and roads over

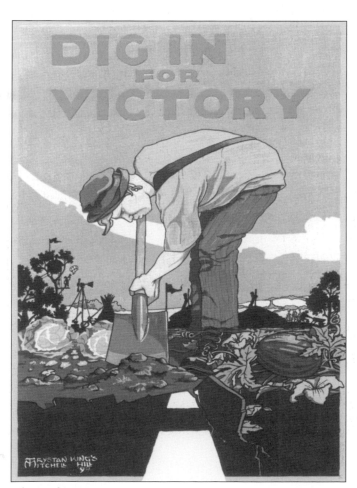

The Land is Ours

growing food. The political importance and depth of feeling associated with land and the right to grow food remains. In the new poster, identity has slipped from a national consensus to an internal conflict.

Several television programmes about allotments appeared on national and regional television. Viewer figures reached millions and the programmes served to spread the awareness of their vulnerability, interest and politics. These are listed at the end of the book.

The popular gardening magazine, *Amateur Gardening*, gave allotments national priority in a year-long promotion of their case.

In 1994 the government department responsible for allotments, the Department of the Environment (now DETR) sponsored a survey of allotments in England in response to strong representation from the National Society of Allotment and Leisure Gardeners who were concerned about the loss of allotment sites to development. [*Survey of Allotments in England*, David Crouch, Anglia University/NSALG Ltd] The survey demonstrated that there had been a significant loss of allotment land in the twenty years since data on allotment sites had last been maintained. The House of Commons Environment Committee called an Inquiry into their future [*The Future of Allotments*, 1998]. The Inquiry heard articulate contributions from numerous individuals, city-based allotment groups and the National Society, as well as further exposition from the earlier Survey. It became evident that allotments were too often misunderstood as remnants of a past need for cheap food. The Inquiry identified that allotments were now a valuable national and community resource for a whole range of things, including healthy exercise, friendship, community building, and sustaining the environment. The Government's policy on sustain-

Aylesbury's Allotments

Get up & Grow!

Aylesbury Vale District Council

ability acknowledges exactly the particular value that allotments supply — popular involvement and activity.

One key result that emerged rapidly from the Inquiry was the requirement placed upon local councils, the main landowner, to promote allotments. Promotion is crucial for the future of allotments for several reasons. Promotion informs prospective plotholders that allotments are open to everybody to rent, and identifies where they are available. Allotments need to be promoted in order to secure the relevant image of what allotments mean for the environment and for local people. There is repeated evidence that the promotion of allotments can secure wide public support, participation and value. Popular awareness of allotments and their value can provide a ready context in which eventual efforts to defend a site threatened with development can be made. To place allotments in the popular agenda can avoid reliance on last-minute reactive politics at the moment of crisis, when often action is too late.

Allotment holders and their societies can play a very important role in publicity that demonstrates the value of allotments to the wider community. This can especially be done through work that involves people from the local community in sharing allotment benefits.

Uplands: Mario Rozanski served as unpaid Secretary for six years. During that time he negotiated numerous differences of opinion and of practice between plotholders, and secured greater mutual understanding between people on a site renowned for its multi-ethnicity. He attached the allotment organisation to the local community with women's self-help groups using the club room, youth directed by local Social Services

developing skills and self- and community-respect through practical work on the site, and a school group using a plot to learn a whole range of skills. Mario worked with a performance artist in the fifty-year multi-ethnic anniversary celebrations and secured significant financial support for the event, and produced a balance in surplus for the association in that year.

There can, however, be limits to involving the wider public in allotment life. There can be a tension between people who really satisfy their interest in looking after their own plot, and those who identify wider possibilities in what allotments can do. The possibility for strains and a dynamic politics at the very local level are evident in the recent drama of Uplands. Some plotholders felt uncomfortable about what they perhaps saw as over-exposure and Mario was ousted from his role in a hard-fought battle.

The importance of networking allotment interests across the wider community cannot be overstated. The case of the Durham Margery Lane site is exemplary. This is a story of considerable political effort amongst plotholders and also one of making an inclusive approach to the world outside the allotments. Links can be made with environmental, civic, social and other local interests in order to embed the value of allotments, and of the allotment site, in the local community.

In Durham city allotment holders contested the sale of their site for building. The site is owned by the Durham Diocese of the Church of England. The Church, ironically, was a key player in the movement to create allotments in the eighteenth and nineteenth centuries.

Mario Rozanski (photo: Carol Barker, The Independent)

"We received notice to quit from the Diocese. It was a developer who wanted to build on the site. Reputedly the Diocese had been offered three million pounds for it. It was very nerve racking while it was going on, the Church is such a big organisation. We could only have done it with the support of the people who live around here, and the local authority who backed us up."

"We objected to it and had a petition, 11,000 people signed it in Durham. We were on all the winter months and had a good go, that's all you can do, have a good go."
[Norman Mollen]

These people won the fight to hold onto their land, partly because of the combined opposition of plotters and the wider public, partly due to the downturn in the land market in the early 1990s. During this time they secured the support not only of the Guardian and other national newspapers, but of the Durham Civic Trust, an interesting change from the perception of allotment sites as eyesores.

Given the diversity and personal commitment involved in particular forms of plant and land cultivation, differences between plotholders are to be expected, and the negotiation of those differences can be a central source of tension, but one that can be creative. People can learn from each other, but sometimes conflict results. Sometimes there can be an argument over a plotholder's lack of cultivation, which can result in a tenant's removal from their plot. However, the tension can be on more than an individual basis and exceed the concerns of properly maintaining a plot. In Oslo, Norway, there is a growing concern for the differences between two groups of cultivators: one generally white and the other immigrant, mainly Turkish [Siri Haarvie,

personal communication]. The first increasingly use their plots decoratively with a variety of flowers to accompany smaller areas of vegetables. The latter clear the large part of their plot for seasonal mass planting of vegetables, with little room for flowers. Both types of plots are well tended, but the landscape they each create is different. Allotment holding may engender friendship and care, but as anywhere there can be a tension in coping with difference.

In several recent debates over the loss of allotment land holders are positioned against people who need homes. In fact, both groups of people share the same difficulties over space in relation to a land market that has other priorities.

> *Over the thirty years to 1997 more than one third of the nearly 600,000 allotment plots were lost. Yet there remain over one third of a million plots, one for almost every fifty households in England.*
> [Survey of Allotments in England, Crouch, 1997]

Several important issues concerning allotment futures and the attitude of the Government arose from the Inquiry mentioned above. The Inquiry favoured allotments. The Government responded to this Inquiry by arguing that legislative changes in land provision and security may be lengthy and over-complicated to achieve. However, local councils, through their joint representative body the Local Government Association, are advised to take a more active combined role in developing the case for allotments and their proper management, including increasing devolution of management to plotholders. Such devolution would enable allotment societies to play a full share in maintaining allotment land for the future.

Growing Places

Winter, Issue 1 2003

Federation of City Farms & Community Gardens

Allotments Regeneration Initiative - Funding News
Open Gardens Open Gates - European Conference
Insurance Update - Young People - Members News

The Inquiry and its widespread support precipitated the (then) Department of the Environment, Shell Better Britain and the Greater London Authority, enthusiastically supported by Ken Livingstone, to fund the production of a *Good Practice Guide to Allotments*. This investigation set out clear guidance for local councils and local allotment societies to enhance the way allotments are managed and maintained and featured in a range of local council policies. Allotments are removed from their long-held ghetto to be in mainstream concern. Areas such as health, planning, sustainable environments and community development are informed and enhanced by allotments as positive contribution to future government action. This guide is of use to anyone seeking to ensure the future of allotments, and their allotment site. Their future should be assured if local councils work to this guidance, and if allotment holders and their broadly-based popular support monitor their progress and demonstrate their interest in active campaigning to protect them.

However, it remains important for allotment holders and their supporters to make sure that they don't retreat into that ghetto and alienate themselves in the process. The familiar image in the local press of the older plotter wielding a fork in demonstration of a determination to defend his site can too easily be read as someone trying to take on — and thereby alienated from — the world. Allotments are a crucial part of everyday life and wider culture, and need to be projected in the same way. Democratic accountability on local allotment sites is a widely-acknowledged quest.

The emphasis on organisation and democracy embedded in the new community garden framework foregrounds concerns not only over land availability and security but also over community participation. In the UK, Community Gardens have emerged in the

last few years as a distinctive type of allotment. One of their distinctive features is that they are situated on land owned by local councils or other agencies but not enjoying the century-old allotment's legislative security. They do not have any legal framework of security, however surreal that protection may sometimes have been in mainstream allotments. However, Community Gardens do provide a new source of allotment land, bringing into temporary use land (derelict sites for example) that is otherwise of no use to the community.

Moreover, Community Gardens require a new kind of site management that is more democratic. On traditional allotments plotters have often felt disempowered or they have lacked interest in looking after their sites and their future. This lack of involvement has led to plotholders only being able to react to events rather than being continuously involved. Community Gardens require a democratic structure and a clear set of rules and responsibilities. The one thousand or so Community Gardens are grouped into the Federation of City Farms and Community Gardens that provides professional skills in setting up these arrangements. These Gardens arise directly from a very new social/cultural focus. They are linked with the idea of mobilising the use of land as a catalyst for community building and identity, and are increasingly being regarded by government as an important part of community development and urban regeneration.

Community Gardens in the UK follow the US model, where community groups seek to re-use abandoned city lots, such as car parks and rough unused ground, for cultivation. They work through local councils, often with very active political measures, although again these have no security of tenure. During 1999 and 2000 there continued a significant protest in

New York where the city Mayor sought to dispose of numerous sites. Supported financially by Bette Midler, this protest of defence continues. [Personal communication, Edie Stone, Green Thumb, New York]. Currently the Community Gardens Federation is negotiating security for sites in the UK.

Almost all allotment sites in Britain are owned by local councils. Most of these are sites 'fully protected' by legal means, known as statutory sites. This classification means that when a local council wants to sell or build upon a site it must receive approval from the Secretary of State. Permission may be granted if there is evidence of significant plot vacancy, a lack of support by plotholders for the site being retained, and evidence that the local council has promoted the site to the public at large. There is a need for the criteria of promotion and the reasons for vacancy to be more clearly set out. More vulnerable are the sites that are local council owned but do not benefit from any legal protection, known as 'temporary sites' which have been used for allotments although never prioritised as allotments for the future. Unsurprisingly it is these sites that have borne the brunt of disposal over recent years.

In the face of the liberal application of procedures for disposal of allotment sites by some local councils, and a lack of active political support from the allotment holders' side, the change of title conferred by Victor Lewis Smith may have increasing relevance: "...despite the ancient rhetoric (and ancient Enclosure Laws Acts that require councils to provide land for urban dwellers), it's clear that allotments are rapidly becoming alittlements."

In view of their contribution to contemporary life it is disappointing that allotments, along with other open spaces, parks and vacant ground, where people can play and imagine, feature little in the

Richard Grassick

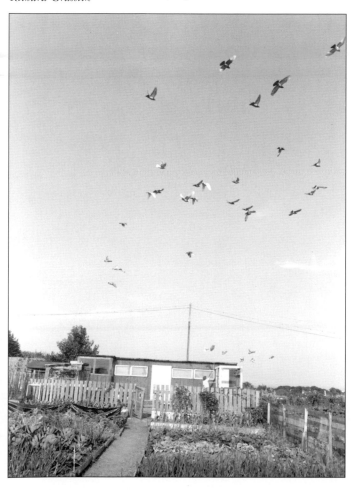

Government report *Urban Renaissance* [1998]. Similarly, the paucity of official debate concerning the way rural land is cultivated or owned overlooks the wider potential that greater diversity in farming practices holds.

> *"One man farms ten thousand acres with three men growing barley. Imagine that cut up into plots for a thousand families to use; orchards, young tree plantations, a myriad of small plots of land and loads of different crops and hundreds of happy and healthy children."*
> [*The Plot*, 1994]

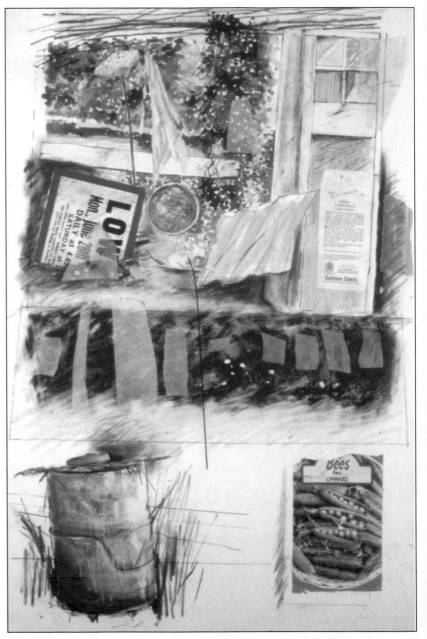

Mike Sparkman (courtesy of Ruth Yarrien)

9. Negotiation: landscape

Mike Sparkman (courtesy of Ruth Yarrien)

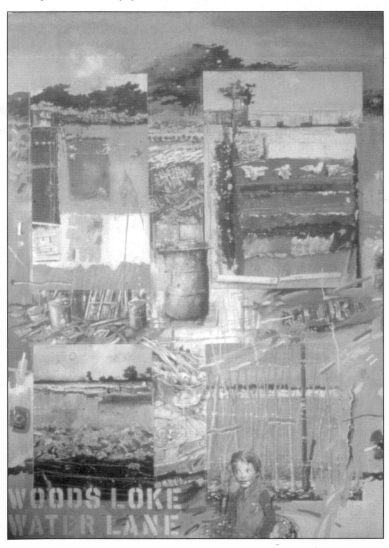

Whether we have an allotment or enjoy them otherwise as a part of the contemporary popular culture of our local environment, we make sense of them in our own way, as these chapters and their illustrations have shown. Through contrasting experiences we produce a kaleidoscope of their landscape, a changing compilation of images, fragmented, like their depiction in the paintings and collages by Mick Sparkman.

[The late] Mick Sparkman's allotment pictures were inspired by his own allotment. He was fascinated by the surroundings of allotments. Nothing wasted — all recycled — pots and pans, tin baths, old enamelled advertising signs, bedsteads, all had a use. Sheds made from old doors and window frames, haphazardly nailed together fused with vegetables and flowers, weeds, puddles and bare earth. And in all his work that thread of pop art and graphic influences — lettering, texture and collage... His work continued to mirror popular culture — music, comic art, fashion and style, combining with his literary influences — he was a prolific reader of both fiction and non-fiction.
[Yarrien, 2000]

These pictures are not only interesting in their depiction of allotments, but also in how they are constructed. These are kaleidoscopes of the different features the plotter encounters working on a plot. They are not views but loose groupings, artistically composed, but placed in

51

the kind of chaotic mix of features that is encountered in bending, turning, glancing, pulling material and moving earth.

Doing allotments, the plotter is likely to claim a higher degree of skill and sorting than Yarrien's words imply, yet her words echo the loose creativity of what many plotholders value. This value includes the freedom and ability to grow things properly and productively and to find expression in growing things, in looking after the land alongside other people. It is this mix of organising the land and grasping freedom through the way it is done, that matters.

Allotments can be the source of diverse and sometimes curious inspiration. The architect Ray Garner was inspired by his experience on allotments to design houses that contain the marks of allotment sheds. Frog Cottage contrasts well with eighties' homes on the adjacent estate.

Wandering around an allotment, or looking over neighbours' plots, is a dynamic encounter with space. Marks of our own effort and what we have tried to do but not achieved may be mixed with memories of earlier plots and sites, with ideas about using land. In the space of the allotment we can imagine and prepare. The allotment is a temporary piece of ground, in legal and in practical terms. Whilst physically bounded from the rest of our lives, in the allotment it is possible to bring together different experiences through the way we use the ground. The plot itself, with its modest dimensions and content, can reflect our life and the negotiations and travails it contains. The allotment as landscape can embrace many proportions of our own life. The plot combines intimacy and an enlargement of our lives.

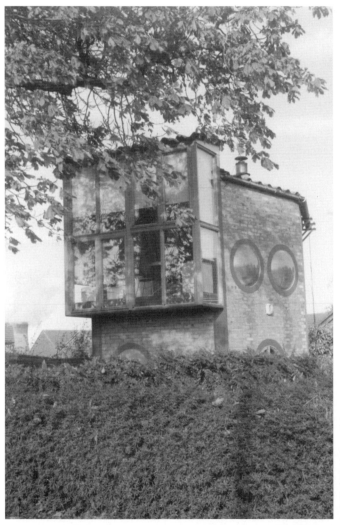

Ray Garner

The plot is a product of what the individual plotholder does, feels and values, within the constraints of time, space, energies and ideas. We draw on references — our metaphors of memory, encounter and popular culture — to make our own sense of things. The direct physical manipulation of the ground that allotment holding enables and requires makes it particularly distinctive in this way. An allotment may look like a piece of open ground, but our activity, along with the interaction with the growing plants, the ground and various materials in use, fills the space with meaning.

As many people have expressed in these pages, the space of the plot, of the site, and in the wider neighbourhood, becomes the space where things happen, the momentary limit of our world. Pictures of plots, things that people do and make, how they feel, are not separate, but relate. We flirt with space, we get to know it, explore it with touch and other senses, compose it, for a while, but our encounter with space is always changing, as our memories are changed with accumulating experience and practice. This renders the plot less of an idyll — although this is often important — but a complexity of life, about coping as well as celebrating, about tensions and working out strategies; possibly of not coping. This activity is inflected with images of the way things might be, with idealised images from popular culture that may also contradict the sense we make of the allotment.

The representations of allotment holding in photographs, paintings and posters interplay and mutually interpret the practice of these places. Visual art can prompt engagement and make it possible to rethink the value and content of cultures and places. In making the images, the artists have frequently encountered many of the feelings and

experiences of the plotholders, and engaged with the physical material that they use. In making their own objects the artists can have the same complexity of encounters as the plotholder, and provoke us, too, to rethink what it all means Looking at the pictures brings us into an encounter with the artists and the people whose work, lives and values they represent. These visual images, rather than being set apart, can engage us in a journey through which we can discover what it is to be a plotholder.

10. Sources, references and influences

Black, Matt *Plot 61* (Spout Publications, 2001)

Crouch, David *Allotments: a viewers' guide* (Channel Four, 1992)

Crouch, David *The Plot* (Community Programmes Unit, BBC2, 1994)

Crouch, David *Report of the Survey of Allotments, England* (Anglia University — National Society of Allotment and Leisure Gardeners Limited, 1997)

Crouch, David (ed) The intimacy and expansion of space *Leisure Tourism Geographies* (Routledge, 1999)

Crouch, David and **Ward, Colin** *The Allotment: its landscape and culture* (Faber, 1988, Five Leaves 1994, new edition 1997) — reprinted 2003

Crouch, David and **Wiltshire, Richard** *Good Practice Guide to Allotments* (Local Government Association, 2001)

Feaver, W *Pitman Painters: the Ashington Group 1934-1984* (MidNAG/Carcanet, 1993)

Ferris, John (ed) *People, Land and Sustainability: a global view of community gardening* (CWS, 2001)

Fryer, Peter and **Rigby, Graeme** *Peaceable Kingdoms: allotment gardens in Newcastle upon Tyne* (Newcastle upon Tyne Leisure Services, 1992)

Harrison, Tony: *The Allotment* in *Abse Dannie* (ed) *Poetry Dimensions 2* (Abacus, 1974)

Hyde, Michael *City Fields, Country Gardens: allotment essays* (Five Leaves, 1998)

Macgregor, Miriam and **Lister, RP** *Allotments* (Silent Books, 1985)

Warner, Sam Bass *To Dwell is to Garden* (Northeastern University Press, 1987)

A Future for Allotments Report of the Inquiry. Environment and Transport Sub Committee of the House of Commons (House of Commons, 1998)

The Thorpe Report: Royal Commission on Allotments (HMSO, 1969)

Cabinet: a quarterly magazine of art and horticulture (www.immaterial.net/cabinet)

Key Allotment Websites
QED Allotments Group Home Page:
www.btinternet.com/~richard.wiltshire/allot1.htm
QED Virtual Potting Shed:
www.btinternet.com/~richard.wiltshire/potshed1.htm

Five Leaves

Cotters and Squatters
Housing's Hidden History
by Colin Ward

176 pages, illustrated, 0 907123 19 8, £9.99

There is a widespread folk belief that if a house could be erected between sundown and sunrise, the occupants had a right to live there. Often enquiry shows this legend to be true: that's the way it happened. Colin Ward's book is full of anecdote and glimpses of surviving evidence of this and other unofficial ways in which people have housed themselves.

Cotters and Squatters explores the story of squatter settlements in England and Wales: from our cave-dwelling recent ancestors to the Diggers and on to the industrial revolution; and from twentieth-century mass squatting to modern claims that "The Land is Ours".

Colin Ward is the chronicler of popular and unofficial uses of the landscape. His many books cover New Towns, holiday camps, tenant control of housing, the plotlands and many examples of "anarchy in action".

Colin Ward is nearly always worth listening to... he casts a sceptical and knowing eye over many of the architectural conceits of our age. THE GUARDIAN

He is the ideal interpreter of the dissidents THE ARCHITECTS' JOURNAL

COTTERS AND SQUATTERS

Housing's Hidden History

"england is not a free people, till the poor that have no land, have a free allowance to dig and labour the commons..."
Gerrard Winstanley, 1649

Colin Ward